MICHELANGELO

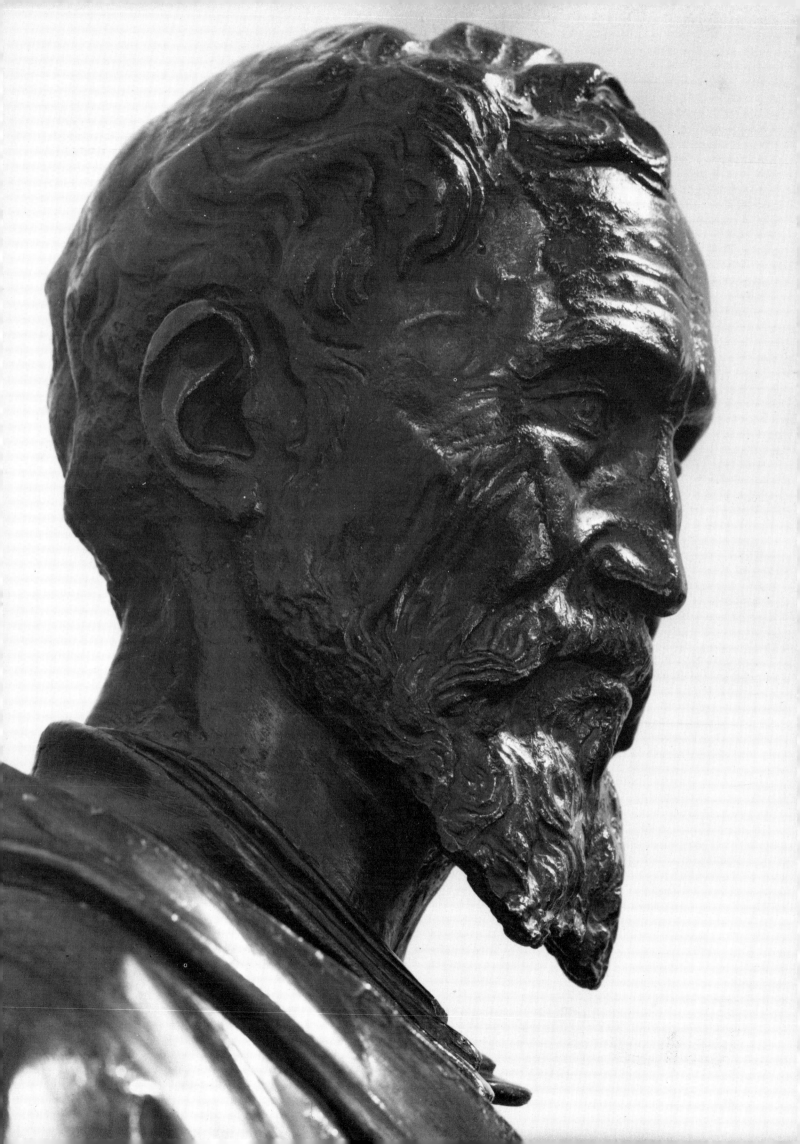

MICHELANGELO
A LESSON IN ANATOMY

JAMES BECK

A STUDIO BOOK

THE VIKING PRESS NEW YORK

Frontispiece. Daniele da Volterra, *Portrait of Michel-angelo* (detail). Bronze. Casa Buonarroti, Florence. (Photo Luigi Artini)

First published in 1975 by The Viking Press, Inc.
625 Madison Avenue, New York, N.Y. 10022

Published simultaneously in Canada by
The Macmillan Company of Canada Limited

SBN 670-47396-0

Library of Congress catalog card number: 74-29472

The plates in this book were printed by
Rapoport Printing Corp., New York, New York
using the Stonetone process.

Printed in U.S.A.

The primary purpose of this, essentially a "picture book," is to demonstrate to artists and art students through selected reproductions Michelangelo's system of fashioning the human body: a demonstration to be studied, analyzed, copied, and, perhaps, opposed or in some cases rejected outright. Raphael had, at least according to Michelangelo's testimony, "learned all he knew" from him. Without question there were prodigious lessons to be discovered in Michelangelo's figures for the artists of the sixteenth century and the centuries that followed, and there are undoubtedly valid indications for their twentieth-century counterparts, especially at a time when an increasingly intense study of the human figure has erupted after more than half a century dominated by abstraction.

The illustrations have been chosen in order to engage the contemporary artist, stimulate him, and offer simultaneously a handbook for rendering human anatomy. The stress is upon Michelangelo's interpretation of the human figure—the driving interest in his activity as a pictorial artist—particularly individual parts of the body. The concerns he displayed in his surviving works in anatomy are quite unlike the more scientific dedication represented by Leonardo and Vesalius, for example, to whom organs and internal systems were pressing considerations. Theirs is an anatomy which still lies at the core of that study as taught even today at medical schools. I believe that Michelangelo's practice was far less theoretical, although there is considerable difference of opinion among scholars on this point.

Preface

Late in life he may well have planned a formal anatomy book in conjunction with a doctor. His official biographer and pupil, Ascanio Condivi, reports the following information:

> *And now to turn to anatomy: he [Michelangelo] abandoned the dissection of bodies because the long handling of such corpses had so upset his stomach that he was able neither to eat nor drink with any profit to himself. It is true that he became so learned and experienced in this study that he had often the mind to write, for the use of those who wish to produce works in sculpture and painting, a work that would treat the range of human movement and physical structure of the body and of the bones, with an ingenious theory found out by him through long practice, and he would have written it were he not unsure of his own skills and he doubted his ability to treat the work with the dignity and grace as one trained in the science and in language would.*

Michelangelo in practice was concerned quite exclusively with the appearance of the body to the eye and the mind's eye and with harnessing that appearance to the reins of his own artistic language and style. His was essentially

an aesthetical anatomy, but he was, after all, a poet. Even though he is known to have undertaken dissections, especially as a young man, his anatomical drawings are more empirical and more approachable on purely aesthetic grounds than Leonardo's. Their purpose was more singularly artistic. In fact, no purely anatomical *écorché* drawings by Michelangelo have survived, although a recent critic has made a case for the attribution of such studies to him.*

The illustrations in this book, many entirely new and never before reproduced, consist of two types of interrelated material. The first, which forms the principal series, is of large photographs of Michelangelo's sculpture (reproductions of his paintings and frescoes have not been included because they are much more familiar, more readily available, and do not illustrate anatomy as effectively), and is devoted to demonstrating parts of the body: torsos, heads, limbs, hands, and feet. These photographs are juxtaposed with a greater number of collateral illustrations of other sculptures or of drawings by the master directly or indirectly related to them. The inclusion of drawings along with illustrations of sculpture has been governed by the instructive nature of such comparisons. The interplay between the three-dimensional world of sculpture and the two-dimensional drawings should provide insights into both forms. The reader will also find in the Introduction a small number of draw-

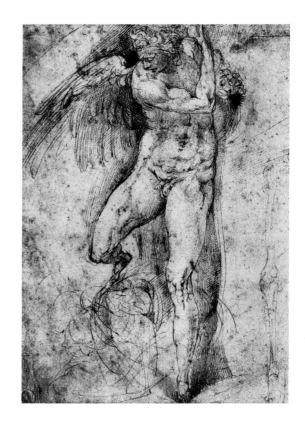

Attributed to Michelangelo, *Figure Study*. Pen. Casa Buonarroti, Florence. (Photo Brogi, Alinari)

* See F. Hartt, *Michelangelo Drawings* (New York: Abrams, 1972).

ings by Leonardo dealing with the human figure, and these have been included to make possible a confrontation between Michelangelo's unique rendering of the figure, his own system of *disegno* — that is, drawing in the broadest context — and that of his most distinguished contemporary.

The text that introduces the book is in no sense a biography of the artist, since there are scores of such studies, fictionalized and factual, and easily obtainable, although a brief outline is provided at the end of the text giving a spare historical guide. The material is not organized into a chronological or stylistic order with appropriate references to the entire range of his creativity from his architecture, sculpture, and painting to his letters and poems. In other words, I have no desire to rehash here old (altogether still perfectly valid) discussions. Instead, together with the two sets of illustrations that themselves establish a special chain of ideas and associations, the Introduction has been conceived as a collage of somewhat fragmentary observations of varying length about Michelangelo, derived largely from statements either by the artist himself or by his contemporaries. In surveying the enormous critical literature on the master and pondering his own words and those attributed to him, and in examining his works once again, some thoughts have emerged that form the essay. The approach is admittedly idiosyncratic, the observations and conclusions are predominately personal, but I hope they will be meaningful and engaging.

All of the translations from the Italian have been made especially for this book and are my own.

I wish to thank a number of friends and colleagues who have in one way or another aided in the making of this book, particularly Signor Luigi Artini whose handsome new photographs are an integral attraction. I should also like to thank Silvano Borghini, Fiorella Superbi, Evelina Borea, Jonathan Riess, Paul Weiss, Barbara Burn, and especially Bryan Holme.

I found the study by Rudolf and Margot Wittkower, *The Divine Michelangelo* (London, 1964), particularly useful.

Villa I Tatti, November 1974

Introduction
A Michelangelesque Collage

Michelangelo was a small and slight man (he probably measured little more than five feet), though the evidence of his statuary might lead to quite the opposite conclusion. The marble *David* must have been three times its creator's actual height, and far more than that in terms of body mass. Michelangelo had, from time to time, envisaged even more gigantic works, and once planned to carve an entire mountainside. Perhaps the monumentality inherent in his vision was akin to Napoleon's, also of similar stature. Michelangelo did not merely sculpt large figures; his measure of the figures in relation to nature and the surrounding environment was grandiose. The spare, short, but wiry Tuscan had to manipulate heavy hammers in order to carve the enormous blocks of Carrara marble he selected; no wonder he made light of Leonardo and painters whose work is less physical. For his part Leonardo belittled the sculptor, who, he said, looks like a baker with a covering of marble dust much like flour. Michelangelo was strong if slight, his hands wrenchlike, his wrists thick and powerful, his forearms bulging with force. In fact, his entire body must have been "overdeveloped" in relation to his frame, compared to the body of Leonardo; the muscles of the torso, the neck, and the back toned like those of an athlete. That he saw and rendered all his figures, male and female, old and young, with similar attributes, may in part at least be explained by his own physical features. Painters, probably inadvertently, often infuse in their portraits and images of other personalities features that reflect their own likeness. An element of

self-portraiture exists in all portraits, and it may be similarly speculated that the treatment of the body coincides with the structure and experience of the artist's own body. Such a generalization has only relative value, but in the case of Michelangelo I believe it is particularly suitable.

Michelangelo in old age was described in considerable detail by his biographer, friend, and pupil Ascanio Condivi, whose account of his physical appearance is a valuable document, and one that has been relied upon in the discussion above. Condivi's text reads:

> *Michelangelo has a good physical constitution; of body rather sinuous and bony than fleshy and fat; above all healthy by nature and because of his bodily exercise and his self-restraint in both sexual intercourse and in eating, although as a child he was sickly. He always has good color in his face; his stature is as follows: he is rather short in height, broad in the shoulders, and the rest of his body proportionate to them, though rather spare than otherwise. The form of that part of the head that is seen from the front is of a rounded figure, in such a manner that above the ears it makes a sixth part more than half a circle and thus the temples project somewhat more than the ears and the ears more than the cheeks, and these more than*

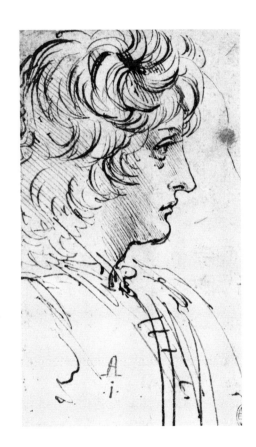

Leonardo da Vinci, *Man in Profile*. Pen.
Royal Library, Windsor.

the rest, so that the head in porportion to the face cannot be called anything but large. The forehead in this view is square, the nose a little flattened though not by nature, for when he was a lad, one Torrigiano de' Torrigiani, a bestial and proud man, almost crushed the cartilage of his nose with a blow so that he was carried home for dead . . . and so Michelangelo's nose, such as it is, is proportionate to the forehead and the rest of the face. The lips are thin, but the lower one somewhat fuller, so that when seen in profile, it projects a little. The chin agrees well with the aforesaid parts. The forehead when seen in profile almost projects beyond the nose and this would appear practically broken were it not for a little hump in the middle. The eyelids have few hairs; the eyes might be called small, rather than otherwise, and of whitish color but variegated and marked with yellow and blue specks. The ears are well proportioned; the hair is black and so is the beard, except that in this seventy-ninth year of his life, the hairs are copiously streaked with white; moreover the beard, from four to five fingers in length, is divided and is not very thick, as may particularly be seen from his portraits.

Condivi's description, dutifully constructed with obvious care, has more value than is often given it (although Vasari takes over much of the account verbatim). The intimacy offered by knowing the appearance of the artist adds immeasurably if unspecifically to establishing a rapport with his art. This familiarity is perhaps even more essential in Michelangelo's case, considering the nature of his art.

Michelangelo was a Florentine (although by accident, as it were, he was born outside the city). No secret, the fact of his "nationality" (for fifteenth-century Italy the word is quite appropriate) is instructive in determining his political sentiments, his business outlook, his social circle in Rome, and, of course, his artistic training, cultural predilections, and unique visual tradition. In fact, all the implications that may be drawn from Picasso's being called "the Spaniard" are equally pertinent for Michelangelo "the Florentine." Raised by, or at least exposed to Lorenzo de' Medici, the Magnificent, Michelangelo in the early years of his adolescence was favored even, it was said, over Lorenzo's own children (including Giovanni, the future Leo X, and a nephew, Giuilio, who became Clement VII). He became nonetheless (or was it a result of this close proximity?) strongly anti-Medicean as an adult, during the period when the heirs of Lorenzo sought unsubtly to impose their absolute hegemony over Florence.

The Florentine republic, re-established after the expulsion of the Medici in 1494, employed Michelangelo to

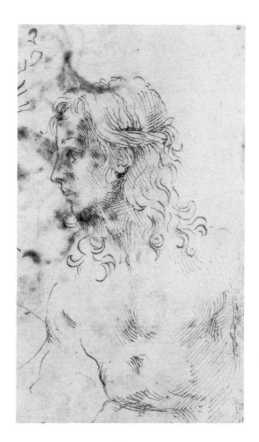

Study. Pen. Ashmolean Museum, Oxford.

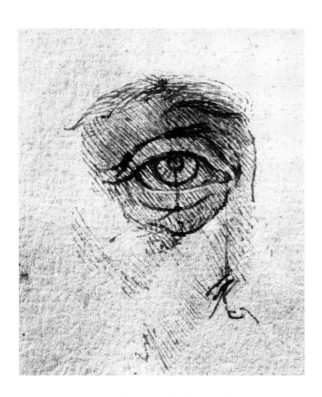

Leonardo da Vinci, *Study*. Pen.
Biblioteca Reale, Turin.

execute two of his most important works, the marble *David* and the never completed mural for the City Hall depicting the *Battle of Cascina,* for which he executed a cartoon known only through fragmentary copies and preliminary drawings. Both works are intensely politicized interpretations, though the artistic intentions are never subordinated to them. Michelangelo's republicanism was allowed free rein.

Later in life, after having been obliged to work for two Medici popes — Leo X and Clement VII — Michelangelo nevertheless risked career and limb by directing the construction of fortifications for the city of Florence against Clement's troops when the republic was briefly restored between 1527 and 1530. Although the pope was eventually successful in subduing Florence, Michelangelo's life was spared, for he proved to be too necessary to the collective ego of the Medici family, whose tombs he was in the course of executing in the new sacristy of San Lorenzo.

If Michelangelo's relations with the Medici were ambivalent and strained, his allegiance to Florence was unflinching: he preferred his servants, even, to be Florentine; there is a recorded instance when he had that excellent saltless bread of Tuscany sent to him in Rome. In a practical sense he was head of the Buonarroti household in Florence, although he was most often in Rome, since he supplied the money, and he continued to be intimately devoted to the affairs of the family and his property and investments in Florence, not to mention the affairs of state. Even after

decades of continuous residence in Rome, he persisted in thinking himself a Florentine and was buried, not in Rome, where his greatest architectural and pictorial triumphs stand, but in Florence's pantheon, the church of Santa Croce.

Michelangelo's observations, comments, and evaluations about art have been collected and evaluated over the centuries, but there are several that occur in a curious book written by the Portuguese painter Francisco de Hollanda and entitled *Tractato de pintura antigua,* but which also could be called *Michelangelesque Dialogues.* Published in the middle of the sixteenth century, the material is based upon Francisco's experiences in Rome a decade earlier. While the conversations that he reports cannot be taken word for word as Michelangelo's, the general thrust and tenor of the statements and the core of meaning are probably those of the Florentine artist; among those I find particularly pertinent are several that deal with the rapidity with which a work (in painting) should be done. Michelangelo is quoted as saying:

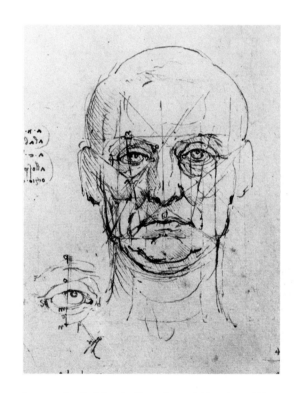

Leonardo da Vinci, *Drawing of Head and Eye.* Pen. Biblioteca Reale, Turin.

> *I shall tell you* [Francisco de Hollanda]; *to make any work with dexterity and rapidity is useful and good, and the power of painting in a few hours that which others paint in many days is a gift of immortal God, and were this not the case, Pausias of Sicyon could not have*

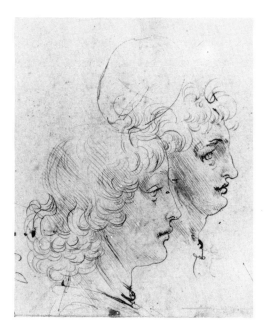

Leonardo da Vinci, *Profiles*. Pen.
Royal Library, Windsor.

worked so as to achieve painting a picture with the figure of a youth perfectly in a day. He who paints rapidly without painting less well than those who paint slowly merits high praise. But if with his speed of hand he passes certain limits that are not permitted in art, then he should, rather, paint more studiedly and slowly because an excellent and praiseworthy man should not let himself be deceived by the taste of his dexterity when it in some measure makes him descend from that great chariot, perfection, upon which he must always ride. Thus it is not a bad thing to paint a bit slowly, or if necessary to spend a great deal of time developing the works, if this is done to perfect them; the only and true defect is not knowing.

And I wish to tell you, Francisco de Hollanda, a great secret of this our science, one that perhaps you do not ignore and keep as the highest, which is: as much as you have to work and study in painting, with great expenditure of time and effort, so much the finished work must appear that it does not seem so worked but painted almost in haste and without fatigue, and very lightly, even though it is not really so. This is excellent advice and an excellent rule.

*Sometimes it occurs that a perfect work
is made with little effort; but this is a rare
thing: it is easier to execute it with the power
of hard work and make it seem to have been
executed quickly.*

Related to the same argument, Michelangelo is quoted as saying:

*I would prefer a mediocre and fast painter
to one of the same value or a little better who
paints slowly.*

Michelangelo's character and temperament, and certain of his artistic objectives, are revealed in an exchange of letters between the artist, then in Florence, and agents of the Medici pope Clement VII in Rome. The correspondence hinges on a proposal on the part of the pope to have an enormous statue erected at the back of the family house on Via Larga in Florence. The pope indicated through an agent, who in turn wrote to Michelangelo, on October 14, 1525, that a colossus be made as high as the crenellations of the Medici Palace, at the corner over against the house of Luigi della Stufa and opposite the barber's. Since the statue was to be so large, the pope suggested that it be made in pieces. Certainly Clement had in mind to allocate it to Michelangelo, who was then also engaged on other Medici commissions, and he suggested that the project be handled

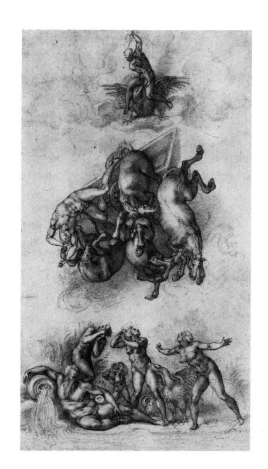

Fall of Phaeton. Black Chalk.
Royal Library, Windsor.

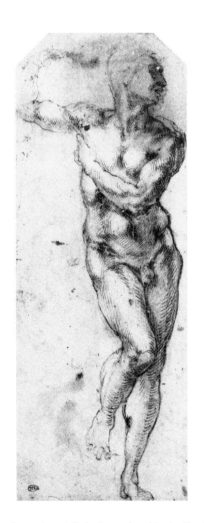

Attributed to Michelangelo, *Nude Study.*
Pen. Louvre, Paris.

with the greatest secrecy. At another point in the letter the pope specified that the height be at least 25 braccia (equivalent to 14.5 meters, or 47 feet, three times the height of Michelangelo's *David*, done two decades before).

In a subsequent letter written two weeks later from Rome, the pope exclaimed his amazement that Michelangelo had not by then made any response whatsoever concerning the colossus. On November 10, nearly a month after the original request, we learn from yet another letter sent from Rome that Michelangelo had failed to make any comment concerning the statue. The pope repeated his desires once more, with the added specification that the colossus face his palace, with its back to the house of Luigi della Stufa. As late as November 29 Michelangelo had failed to respond to the by now constant pressure from Rome regarding the statue. A letter of December 23 informs us that Michelangelo had finally answered the pope's request for a comment on the proposed colossus; Clement is quoted as reminding Michelangelo that what he had asked was in complete seriousness and that, in fact, he wanted Michelangelo to make the statue, provided he had the time to do so.

Michelangelo's much awaited response, written sometime between November 29 and December 23, 1525, is extant, along with a first draft, and throws considerable light on the artist and his ideas about sculpture, not to mention evidencing his stinging wit. My translation of this remarkable letter (preserved, it may be added, in the Laurentian Library which Michelangelo designed) reads:

*To my dear friend Giovan Francesco, priest
of Santa Maria del Fiore [the Duomo],
Florence, in Rome. Messer Giov Francesco.
Had I as much strength as I had pleasure from
your last letter, I think I could conduct to
completion, and quickly at that, all those
things about which you have written me; but
because I do not have much, I'll do what I
can. As you advised me, I have given a good
deal of thought to the colossus forty braccia
[about 78 feet] in height that should go, or
rather that should be placed, as you indicated
to me, over against the corner of the garden
loggia of the Medici Palace and Luigi della
Stufa's house; it would not be good on that
corner because it would take up too much of
the street; but on the other corner, where the
barbershop is, it would, in my view, be much
better, since there it would have the square in
front and would not clutter the street so. And
perhaps since permission might not be
forthcoming to remove the shop, for love of
the income, I thought that the figure could be
made seated and the backside would be
sufficiently high so that the barber shop could
go underneath, and because the work would
be made hollow inside, as it would be
suitable to make it in pieces, the rent*

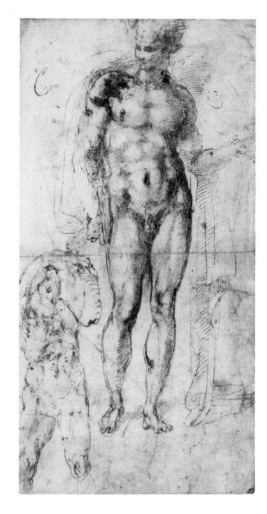

Studies. Pen. Louvre, Paris.

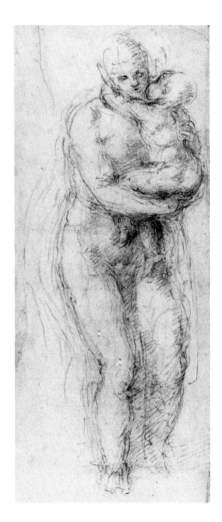

Madonna and Child. Black chalk.
British Museum, London.

consequently would not be lost. And since
the aforementioned shop has at present an
exhaust where the smoke is expelled, I
thought of making a horn of plenty for the
statue to hold, hollow inside, which would
serve as a chimney. Then, since I would have
the head of such a figure hollow inside like
the other parts, I think also that some use
could be made of it. Here in the square
[*Piazza San Lorenzo*] there is a peddler, a
great friend of mine, who secretly told me
that it could be made into a fine spot for the
raising of pigeons. Another notion that might
be much better occurred to me but it would
necessitate making the figure somewhat
larger, although this could be done because
with separate pieces you can [even] make a
tower. The idea is that its head could serve
as the belfry of San Lorenzo church, which is
in dire need of one; throwing in the bells and
with the clanging coming out of the mouth,
it would seem as though the colossus would
be crying misericordia, especially on feast
days when the bells are rung more often and
when the larger ones are used. Concerning
the transportation of the marbles for the
aforementioned statue, so that no one might
know about it, my idea is to bring them in at
night, well concealed, so that they cannot be

seen. There might be a little danger at the city gate but even for this we'll find a way; if worse comes to worse the San Gallo gate, which keeps its customs booth open until daybreak, is always available. . . . As for doing or not doing the things there are to accomplish . . . it is better to leave them to those who are entrusted to do them.

For its outspokenness and sarcasm, especially considering that his words were destined for the pope's ears, this letter is unique among the surviving correspondence of Michelangelo. First it should be realized that Michelangelo has seriously exaggerated the height of the statue; the pope mentioned a measure of 25 braccia in his original request. Michelangelo in the opening part of his letter increased the height to 40 braccia, as if to give warning that his answer will represent a deliberate distortion of a project which, from the start, he must have thought ridiculous. Within the text of the letter the colossus continues to grow in size in almost geometric proportion, so that further on he mentions the statue as the same 40 braccia but seated instead of standing, in effect expanding the figure by one third. Subsequently Michelangelo further enlarges the figure when he suggests that the head could serve as the bell tower for San Lorenzo.

Michelangelo rejects the placement proposed by the pope for his statue, using as an excuse the explanation that it would be seen better in a different location. But by

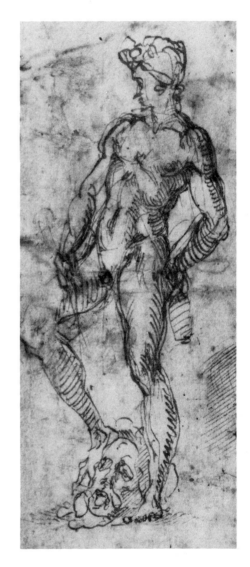

Study. Pen. Louvre, Paris.

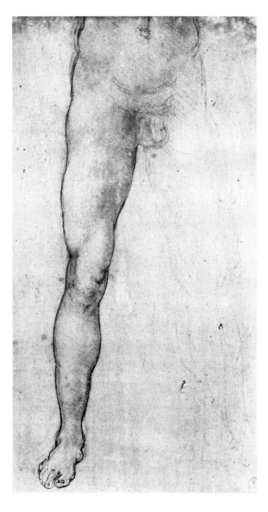

Leonardo da Vinci, *Male Nude Seen from Waist.*
Red chalk and pen. Royal Library, Windsor.

removing the colossus from the Medici Gardens, he entirely undercut the motivation of the pope, who wanted a Medici statue on Medici grounds. Michelangelo sought instead to make the statue public, thereby de-emphasizing the Medicean connotation as much as possible. His suggestion of removing the colossus from the garden corner to the barbershop across the street should be read as a serious rebuff to the pope, one that reflects his anti-Medici sentiments.

Relocating the work over the barbershop allowed Michelangelo to introduce another series of sarcastic comments. He remarks that, essentially, the Medici being so mercenary (they were, after all, bankers, or, if you will, moneylenders), they might not permit the abolishment of the barbershop for "love" (a word Michelangelo must have selected with particular relish and one that did not appear in the first draft of the letter) of the income; this was anything but a subservient remark directed at ingratiating himself with the reigning pope, who was then, be it remembered, his principal patron.

Another theme is introduced at this point in the letter: Michelangelo speaks of making the statue hollow, taking up the pope's original recommendation that the colossus could be constructed in separate pieces. One can readily understand that this suggestion by Clement, repeated several times in the correspondence and perhaps in his own mind something of a brainstorm, was a concept that was in direct opposition to Michelangelo's own practice and his entire

attitude toward sculpture itself. Michelangelo conceived of his figures already within the block and sought merely to "free" them from the excess marble that imprisoned them; the statue and the block were inseparable. Building a work in pieces would have blatantly violated this principle of conception and realization of sculpture and must have been unacceptable to the artist. His ridicule of constructing (rather than carving) the work in pieces with the interior hollow became the leitmotif of the entire letter. This process would allow only for the bizarre: a chimney for the barbershop, a pigeonhouse in the head, or a belfry. The height of the statue could be increased at will, like a tower, but a figure or a gigantic statue without the "idea" of the figure within the stone, without a precise scale, must have been an intolerable concept to Michelangelo.

Another theme that Michelangelo alludes to several times in his much awaited response takes its cue from the pope's desire for secrecy. The sculptor recounts how a street peddler (what an appropriate source!), in *secret*, advised him of the possibility of using the head of the colossus as a dovecote. Hence the absurdity is magnified. In the same vein he makes some cynical suggestions as to how to provide for the stone secretly, for Michelangelo knew all too well that if massive blocks of stone were brought into the city either by day or by night, even if camouflaged (but could such monstrous blocks really be concealed?), the news would travel throughout the city almost immediately. It might be added that the pope's desire for silence must

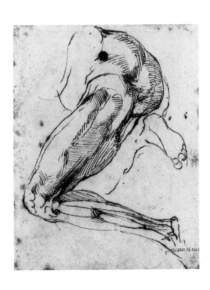

Studies. Pen. Casa Buonarroti, Florence.
(Photo Gabinetto Fotografico)

Study. Leadpoint and pen.
British Museum, London.

have been generated by his fear that strong objections would be raised to such a colossus in many quarters of the city, on both political and aesthetic grounds.

The impertinent suggestion of the chimney for the barbershop reflects further Michelangelo's dissatisfaction with the proposal as a whole. The addition of a cornucopia to disguise the exhaust should be read as additional evidence of his disgust with the pope's complete disregard for meaning or theme for his much desired statue. What kind of significance might such a figure possess, if for "practical" reasons a horn of plenty could be casually added? Such an attribute has very particular conventional meaning. It must have been unthinkable for an artist like Michelangelo to make a colossus or, for that matter, any work whose import or iconography was of so little consequence. Hence Michelangelo indirectly (and perhaps not entirely so) belittled the pope's suggestion on these grounds too, a further sign of his complete disapproval of his patron's motivation and intelligence. To be sure, the concept of an enormous, meaningless (and naked?) statue sitting atop a barbershop and looking over the busy market square is, after all, one of near lunacy.

Michelangelo must have had good reason to believe that Clement would not overreact to his letter, as indeed was the case. In a letter written to Bartolomeo Ammannati some thirty years later, Michelangelo described a project for the completion of Saint Peter's in highly cynical and derogatory terms. The architect (San Gallo) would, Michel-

angelo claimed, remove all the light that was originally planned by Bramante (the first architect of the building) and not provide alternative light sources. The church would be so dark that there could very easily take place a vast range of "indecencies, as secretly hiding exiles, making counterfeit money, impregnating nuns, and other indecencies, in such a degree that when the church is shut, twenty-five men would be required to find those hidden inside. . . ." This sharply worded and colorful attack is a rhetorical parenthesis to the letter, unlike the one to Clement about the colossus, whose tone reflects a unified literary expression. The tempered reaction on the part of Clement raises one final point about the nature and tone of Michelangelo's letter. It should not be taken entirely as an affront to the pope, because this form of writing had a certain tradition in the Renaissance. Broadly speaking, it is related to the *facezie*, or lively, pungent, witty anecdotal stories and sayings, as well as to the sharply worded letters that circulated widely. But such a popular literary expression would not have been possible were not Michelangelo and Clement intimates. It should be recalled that Giulio de' Medici (Clement VII) and Michelangelo, who was three years his senior, knew each other as adolescents in the house of Lorenzo the Magnificent, and that the particular form of intimacy characterized by childhood associations is practically unalterable later on in life, regardless of the changes in condition of the parties. In this case it must have been the unexpressed factor in the subsequent relationship and within the letter under discus-

Studies. Red chalk and pen. Ashmolean Museum, Oxford.

Studies. Black chalk. Teylers Stichting, Haarlem.

sion. Clement was the illegitimate son of Lorenzo's brother Giuliano, who was murdered during the Pazzi conspiracy of 1478, and Lorenzo took over the responsibility of raising the boy, who became very close to his older cousin, Giovanni, subsequently Leo X, and another cousin, Giuliano (Duke of Nemours), the patron, incidentally, of Leonardo, and a friend of Michelangelo. Michelangelo immortalized Giuliano in the Medici Tombs. These long-standing associations between Michelangelo and members of the Medici family in the last analysis provided the ground rules for this unusual letter.

Nothing came of the project for the colossus.

The death of Michelangelo in Rome on February 18, 1564, resulted in general, if not unexpected, lament (for he was, after all, eighty-nine years old), but it was the Florentines who claimed the body and conducted the funeral. The body was carefully packaged and sent to his native city according to Michelangelo's expressed wish. There the newly founded Academy which had previously elected Michelangelo as "head, father, and teacher of everyone" and "*primo Accademico*," prepared to conduct the ceremonies for its most illustrious and distinguished colleague. The body was carefully wrapped in linen for shipment and great pains were taken that no harm would come to it; in Florence the sad cargo was inspected and then sealed at the customs house, whence it was deposited first with the Compagnia dell' Assunta and then ceremoniously

transferred by the Academicians to the Franciscan church of Santa Croce, where Michelangelo's family was buried. The news of the body's arrival spread, and the friars of Santa Croce had difficulty in controlling the crowd that gathered to pay homage to the artist on his last trip home. Once inside the church, the coffin was opened. Much later, on July 14, 1564, the official obsequies were conducted for the deceased artist in the Medici church of San Lorenzo with elaborate decorations and appropriate eulogies.

Two aspects of the events that surround the circumstances in Santa Croce interest me particularly. The vice-president of the Academy, Vicenzo Borghini (Duke Cosimo was honorary president), decided to open the coffin so that those who had never seen the great man, absent so long in Rome, or those who had seen him only decades before, could rest their eyes once again on him for the last time. Contrary to expectations (he had already been dead for more than three weeks, after which span the body normally becomes putrefied and disfigured), there was no foul odor whatsoever and he appeared as if resting in a sweet and reposeful sleep, although the coloring in his face was that of death. The body, we are reassured by several contemporary accounts, was entirely intact. A century and a half later, the coffin was once again opened, and at that time the cadaver was still intact, although in a further exhumation undertaken in 1857 it had been reduced to ashes.

It was universally believed that bodies of the saintly stay fresh long after death, while those more usual mortals quickly

decay and become foul smelling. The "divine" Michelangelo clearly belonged among the saintly. Perhaps aromatics or embalming techniques were used on his body, but contemporary reports fail to mention this and I should prefer to think otherwise, along with Borghini, who at the time of the ceremonies at Santa Croce commented that it was a divine sign that the body was not decayed.

A second curiosity occurred during the celebrations at Santa Croce: all of the Academicians, one by one, approached the body and touched the face and cheeks (which they found soft and lifelike) of Michelangelo, as if acting out some ancient ritual. While they hardly could have believed overtly in the miraculous powers of touch, perhaps it was their unexpressed hope that through the touch, some of Michelangelo's powers would pass on to them, to enrich their art.

> *Michel più che mortale angiol divino*
> (Michel more than mortal divine angel)
> Ariosto

1475—March 6. Michelangelo born (in Caprese).
1489—Works in Medici Gardens to learn sculpture and is taken into the household of Lorenzo the Magnificent.
1496—Goes to Rome where he probably works on the *Bacchus.*
1497—Signs contract for the *Pietà,* located in Saint Peter's.
1501—Commissioned to do the marble *David.*
1504—*David* completed.
Works on *Battle of Cascina* cartoon.
1505—Receives commission for the Tomb of Julius II in Rome.
1506—In Bologna for a bronze statue of Julius II.
1508—Statue of Julius II finished in Bologna.
Called to Rome to execute the ceiling of the Sistine Chapel.
1512—Ceiling of the Sistine Chapel finished.
1519—Medici Chapel in San Lorenzo begun.
1523—Works on plans for the new library at San Lorenzo.
Giulio de' Medici becomes Pope Clement VII.
1527—Rome sacked by imperial troops.
—Florence proclaims itself a republic.
1529—Directs the fortifications of Florence.
1535—Preparations for painting the *Last Judgment* in the Sistine Chapel.
1538-9—Plans begun for the remodeling of the buildings on the Capitoline Hill.
1542—Final contract drawn up for the Tomb of Pope Julius.
—Paints the Pauline Chapel in the Vatican.
1545—The statues of Moses, Rachel, and Leah, all executed by Michelangelo, placed on the Tomb of Julius.
1546—Takes over the direction of the building of Saint Peter's.
1559—Makes designs for the church of San Giovanni dei Fiorentini in Rome.
1564—February 18. Dies.

MICHELANGELO
Chronological Outline

List of Plates

All of the works reproduced in this book are by Michelangelo unless otherwise credited in the following list. Those works attributed to "School of Michelangelo" may have been executed by followers of the artist; "after Michelangelo" indicates a possible copy or version; and "attributed to Michelangelo" means that the work may have been by the artist's own hand, according to many critics. Drawings from the Royal Library at Windsor Castle have been reproduced by gracious permission of Her Majesty Queen Elizabeth II.

1. *David,* detail. Marble. Accademia, Florence. (Photo Brogi, Alinari)
2. *David,* detail. (Photo Alinari)
3. *Giuliano de' Medici,* detail. Marble. New Sacristy, San Lorenzo, Florence. (Photo Brogi, Alinari)
4. *Study of a Head* (Julius II?). Black chalk and leadpoint. Uffizi, Florence. (Photo Gabinetto Fotografico)
5. School of Michelangelo, *Study of an Ear.* Black pencil. Uffizi, Florence. (Photo Gabinetto Fotografico)
6. *Study of a Head.* Red and black chalk. British Museum, London.
7. *Study of a Head.* Red chalk. Casa Buonarroti, Florence. (Photo Gabinetto Fotografico)
8. *Study of a Woman's Head.* Red chalk. Casa Buonarroti, Florence. (Photo Gabinetto Fotografico)
9. *Studies of a Head.* Red chalk. Casa Buonarroti, Florence. (Photo Gabinetto Fotografico)
10. School of Michelangelo, *Head of Cleopatra.* Chalk. Uffizi, Florence. (Photo Gabinetto Fotografico)
11. *Bacchus,* detail. Marble. Bargello, Florence. (Photo Luigi Artini)
12. *Night,* detail. Marble. New Sacristy, San Lorenzo, Florence. (Photo Alinari)
13. *Medici Madonna,* detail. Marble. New Sacristy, San Lorenzo, Florence. (Photo Luigi Artini)
14. *Head Study.* Black chalk. Louvre, Paris.
15. *Bruges Madonna,* detail. Marble. Notre Dame, Bruges. (Photo Gabinetto Fotografico)
16. *Figure Studies.* Pen. Louvre, Paris.
17. *Pitti Madonna,* detail. Marble. Bargello, Florence. (Photo Bazzechi)
18. *Madonna and Child,* detail. Marble. Bargello, Florence. (Photo Gabinetto Fotografico)
19. After Michelangelo, *Head of a Damned Soul.* Black chalk. Uffizi, Florence.
20. *Studies.* Black chalk and pen. British Museum, London.
21. *David.* (Photo Alinari)
22. *David,* detail.
23. *David,* detail. (Photo Brogi, Alinari)
24. *David.* (Photo Alinari)
25. *Five Figures, Nude and Draped,* detail. Pen. Musée Condé, Chantilly. (Photo Giraudon)
26. *Bacchus.* (Photo Luigi Artini)
27. Artist unknown, *Studies after Statue of Dawn.* Black chalk. Uffizi, Florence. (Photo Brogi, Alinari)
28. *Dawn.* Marble. New Sacristy, San Lorenzo, Florence. (Photo Gabinetto Fotografico)
29. *Dawn,* detail. (Photo Brogi, Alinari)
30. *Dawn,* rear view. (Photo Gabinetto Fotografico)
31. *Studies.* Red chalk. British Museum, London.
32. *Studies.* Red chalk. Teylers Stichting, Haarlem.
33. *Studies for the Libyan Sibyl.* Red chalk. Metropolitan Museum of Art, New York.
34. *Figure Study.* Pen. British Museum, London.
35. *Figure Study.* Pen. Casa Buonarroti, Florence. (Photo Alinari)
36. *Bacchus,* detail. (Photo Luigi Artini)